# ANIMAL EXPRESSIONS

## BY JUDITH HAMILTON

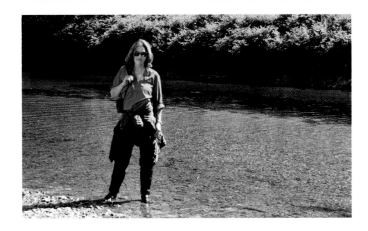

Recently I read Charles Darwin's book, "The Expression of the Emotions in Man and Animals" published in 1872. I was amazed to learn people in that era did not believe animals had emotions.

As I studied my photographs of wild animals, I could see expressions like joy, curiosity, suspicion and love. This insight inspired me to author this book. It is my hope that you enjoy it and appreciate the emotional side of animals.

Many of these photos were taken at some of the 550 sites around the world where Wildlife Conservation Society (WCS.org) works to save wildlife and habitats. Half of the proceeds from this book will be donated to WCS to help them continue their work.

Judith Hamilton
January 2016

The supreme happiness of life is the conviction that we are loved.

Victor Hugo

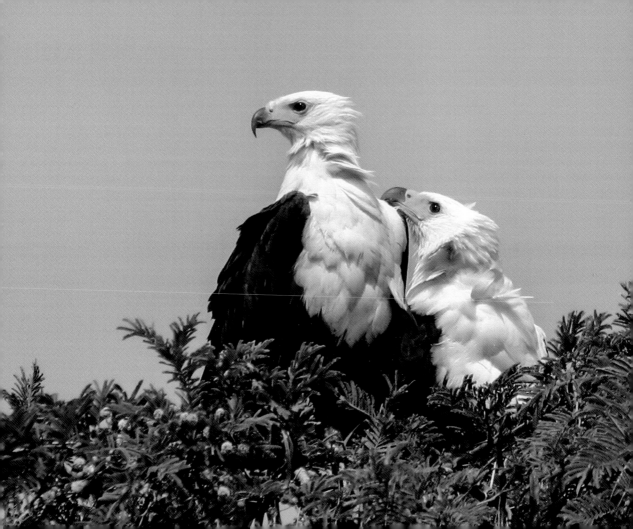

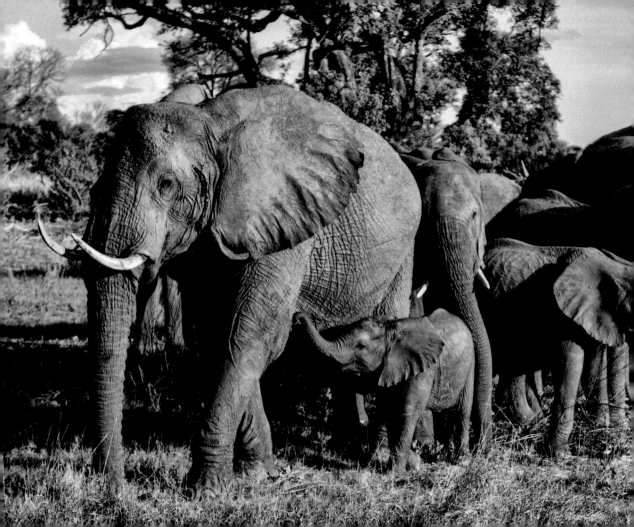

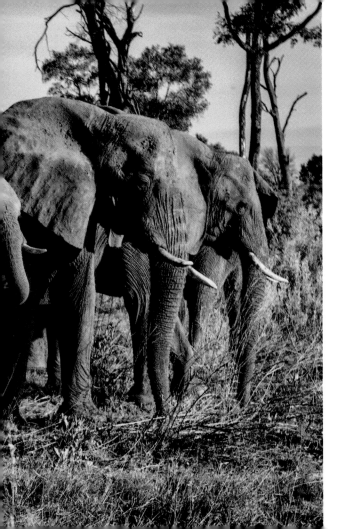

The family is one of nature's masterpieces.

George Santayana

Allow children to be happy in their own way.

Samuel Johnson

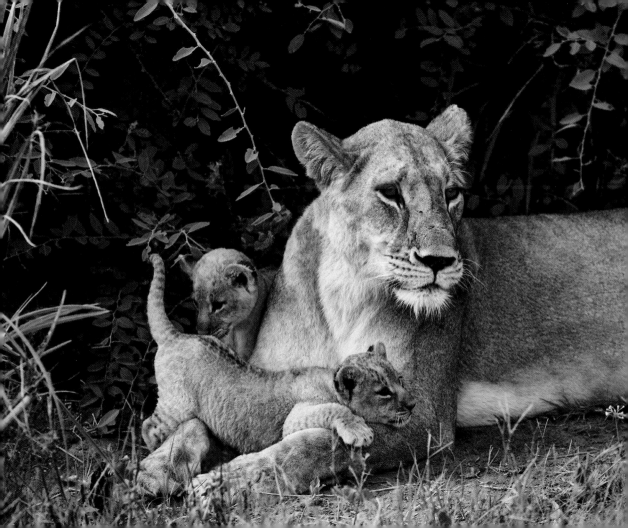

All for one and one for all.  United we stand
and divided we fall.

Alexander Dumas

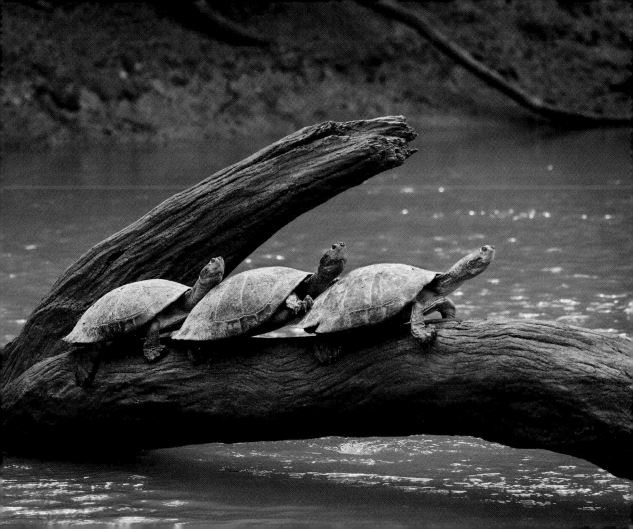

Find a job you enjoy doing and you will never have to work a day in your life.

Mark Twain

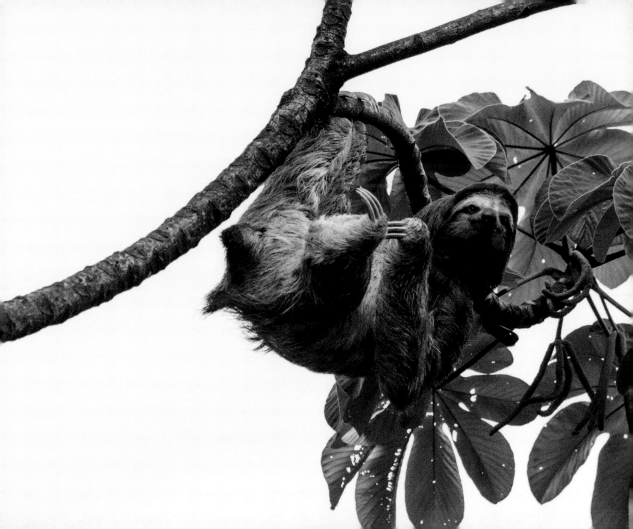

Most folks are as happy as they make up their minds to be.

Abraham Lincoln

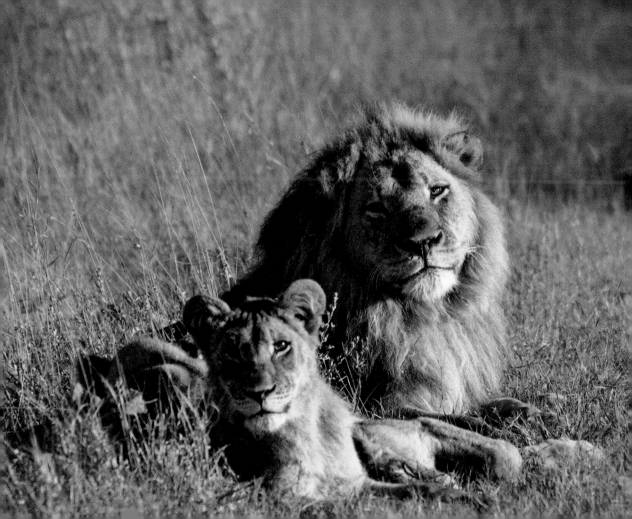

On matters of style, swim with the current.
On matters of principle, stand like a rock.

Thomas Jefferson

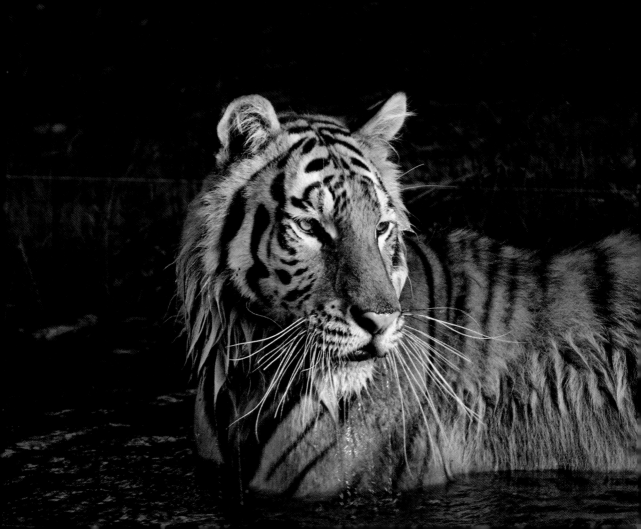

All truly great thoughts are conceived by walking.

Friedrich Nietzsche

What does she want him for when she has me?

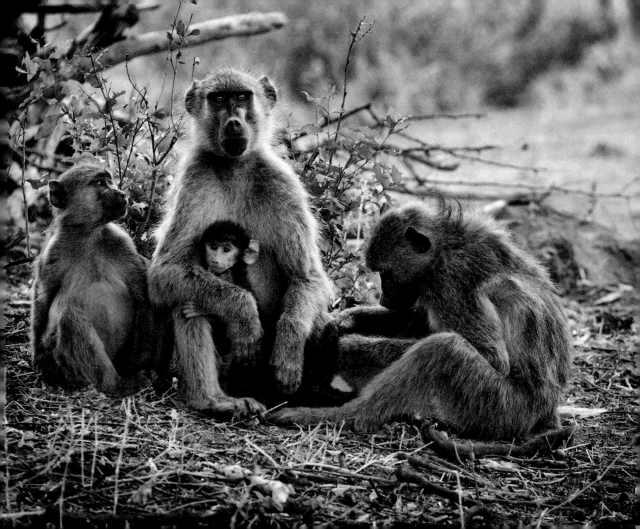

Sometimes it is best to hide in plain sight.

David Estes

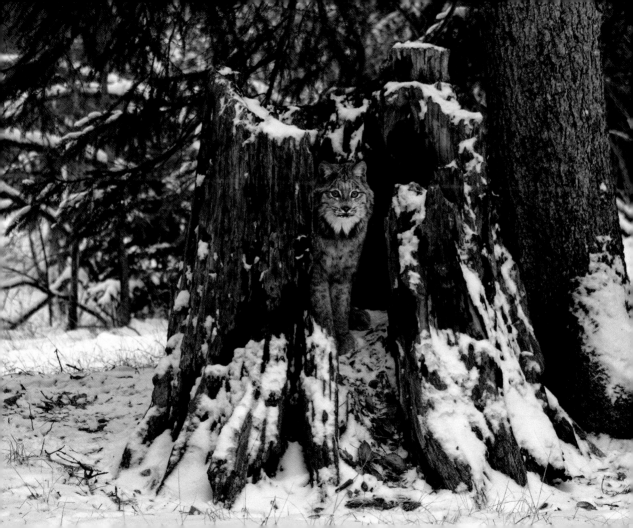

I am not crazy, my reality is just different from yours.

Lewis Carroll

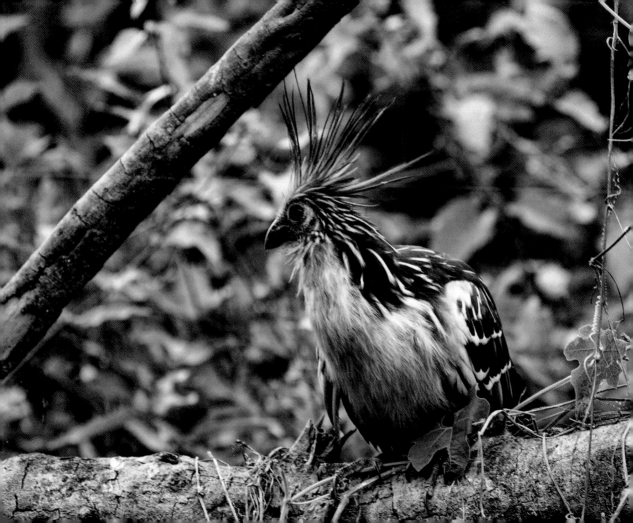

You can study gravity forever without learning to fly.

Shawn Achor

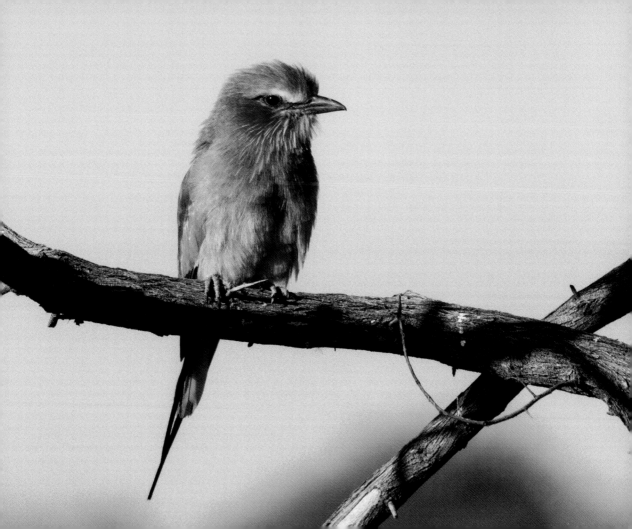

Wash your face every morning in a bath of praise.

Charles Spurgeon

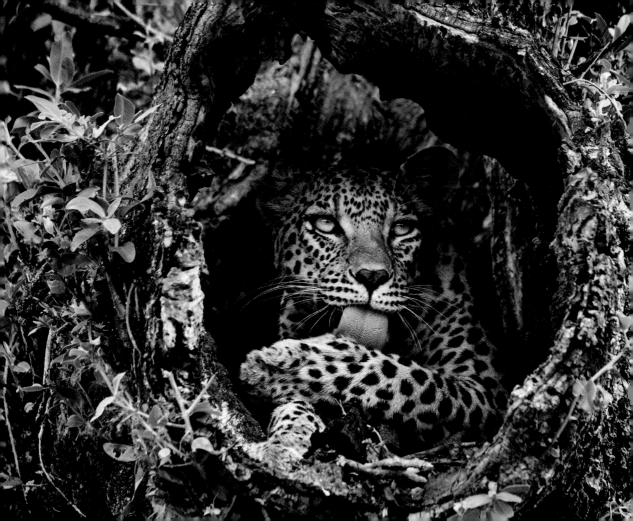

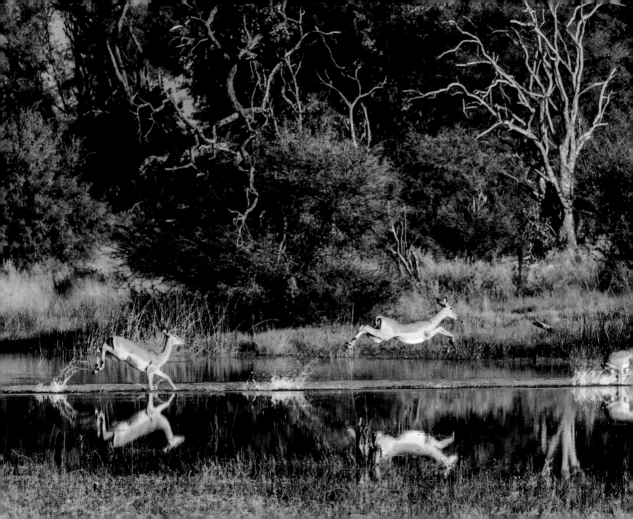

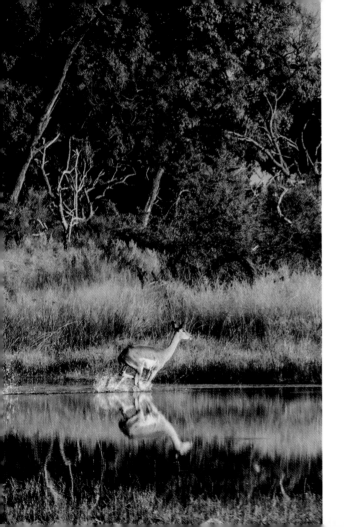

Look before you leap.

Beauty is in the eye of the beholder.

Plato

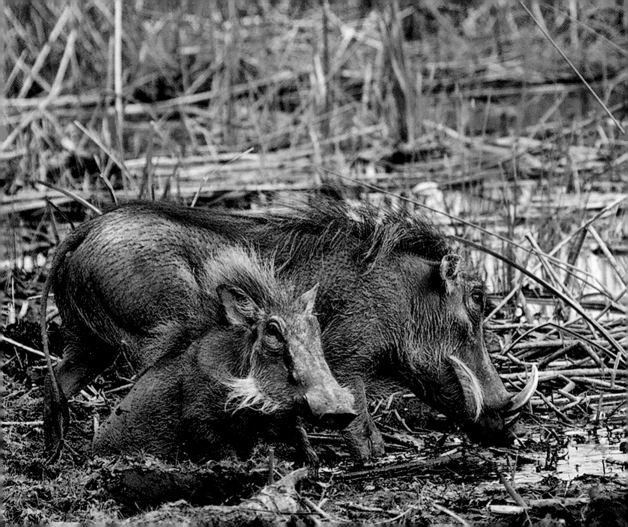

Why not go out on a limb?
That is where the fruit is.

Mark Twain

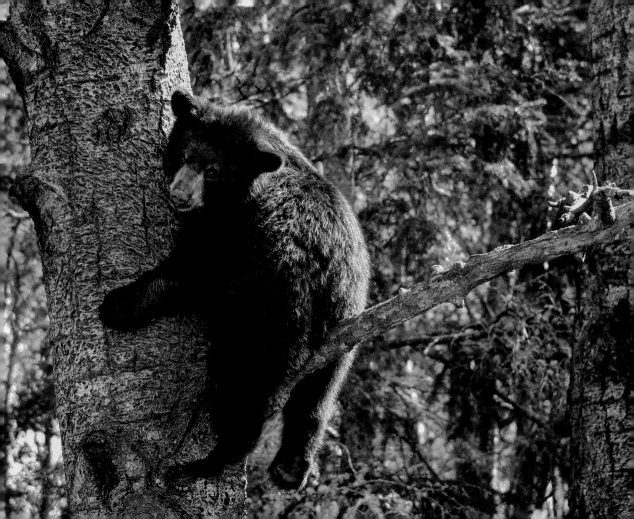

Tell them Dear, if eyes were made for seeing,
then beauty is its own excuse for being.

Ralph Waldo Emerson

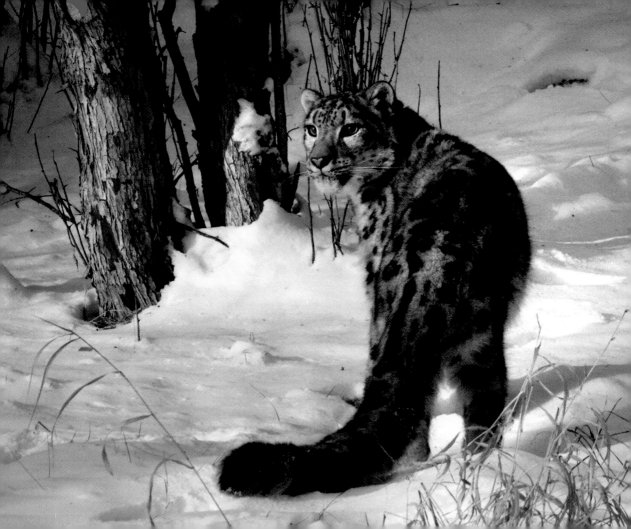

In art and dreams, you may proceed with abandon.
In life, you must proceed with stealth.

<div align="right">Patti Smith</div>

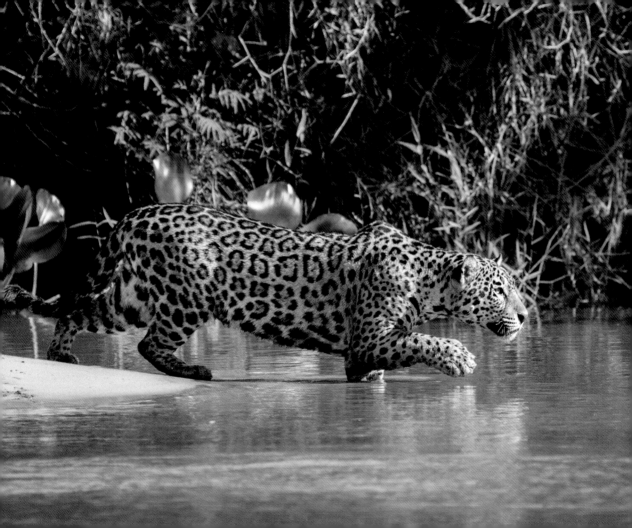

Give a man a fish, feed him for a day.  Teach a man to fish,
feed him for a lifetime.

Confucius

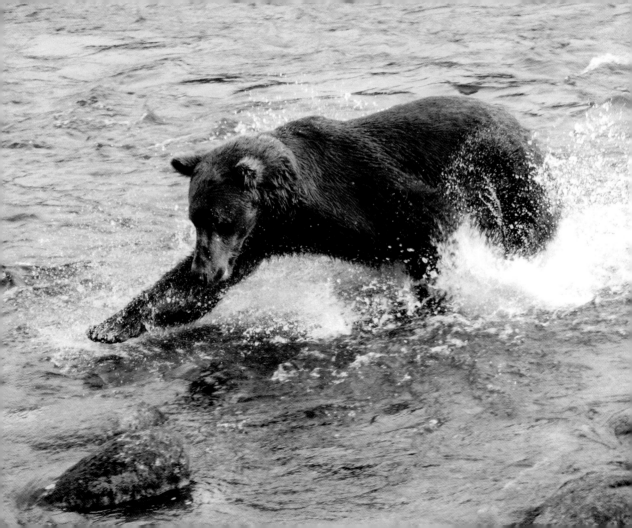

Caution is the eldest child of wisdom.

Victor Hugo

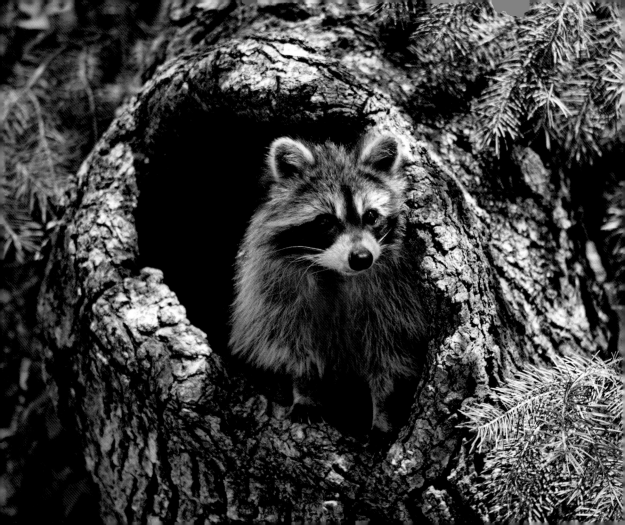

Be happy in your own skin.

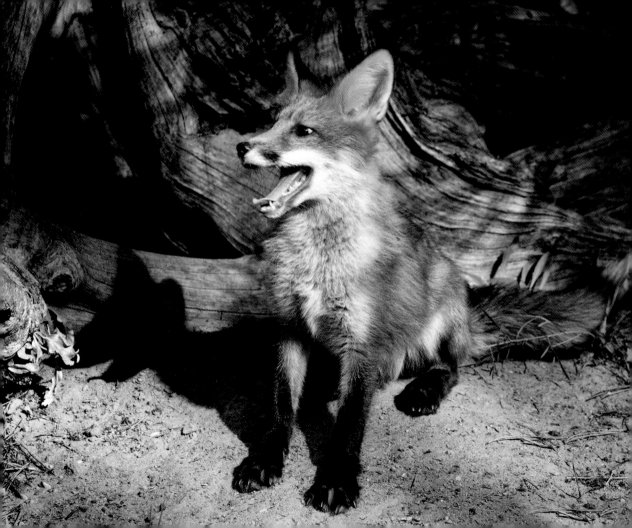

What hath night to do with sleep?

John Milton

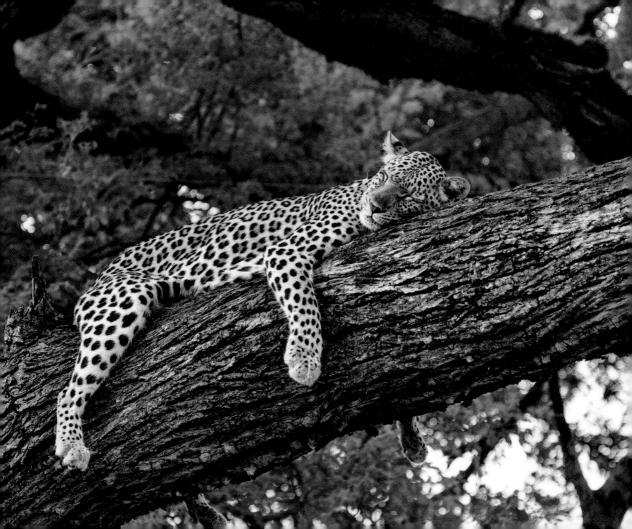

There is no friendship, no love, like
that of the mother for the child.

Henry Ward Beecher

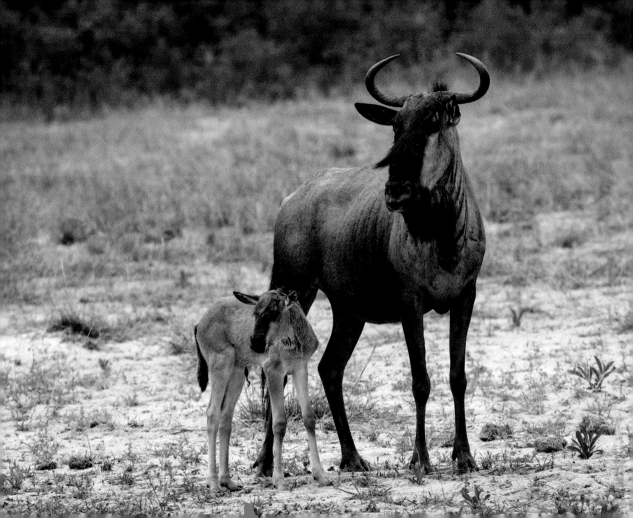

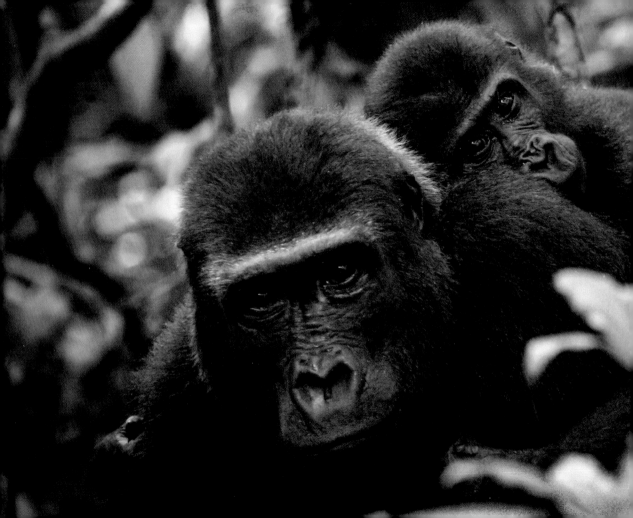

A baby is Nature's opinion
that life should go on.

Carl Sandburg

Family means no one gets left behind or forgotten.

David Ogden Stiers

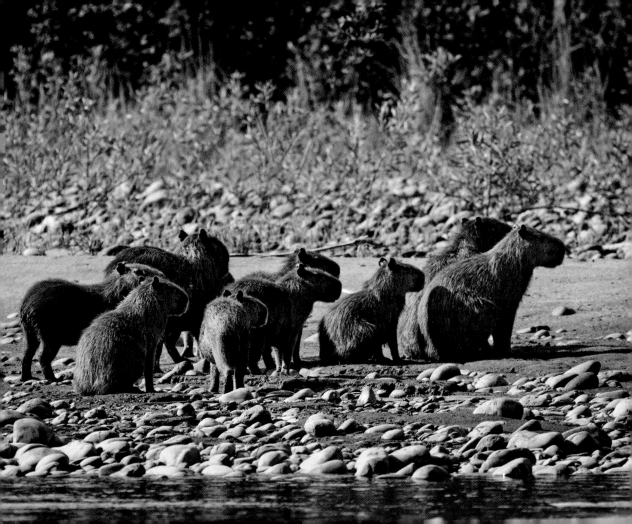

He will win who knows when to fight
and when not to fight.

Sun Tzu

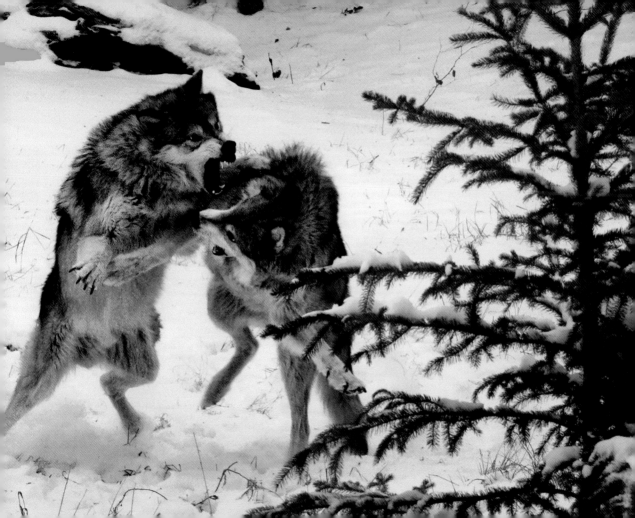

Part of the success of life is to eat what you want.

Mark Twain

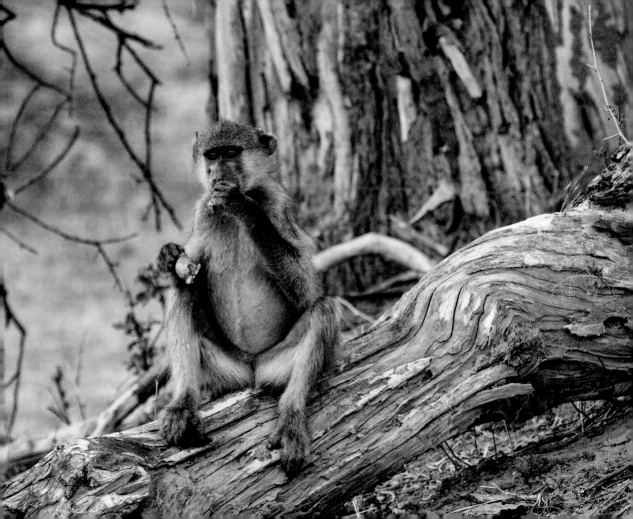

Everything is relative.

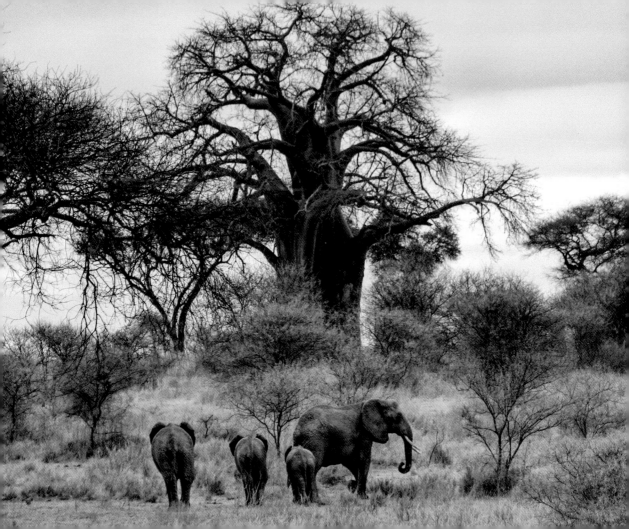

My opinion is that anybody offended by breast feeding is staring too hard.

David Allen

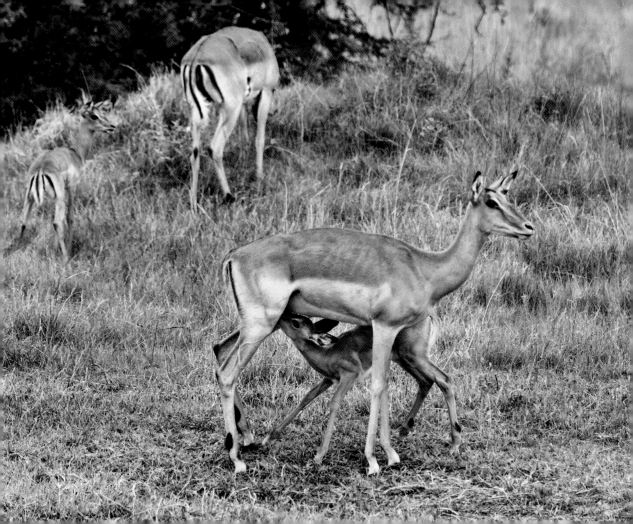

True friendship is when two friends can go in opposite directions but still be by each other's side.

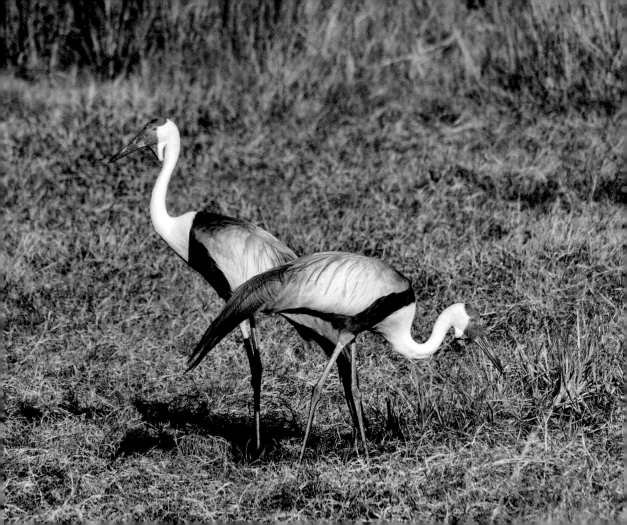

If you want to know where your heart is, look to where your mind wanders.

Walt Whitman

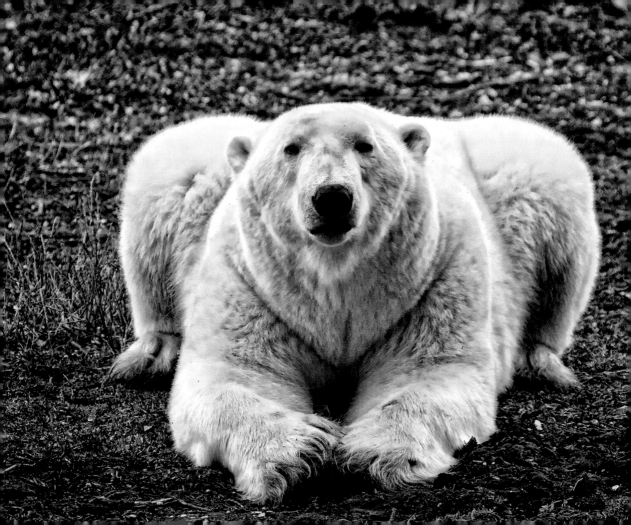

It is always better, in this world, to be a little suspicious.

Wolfgang Amadeus Mozart

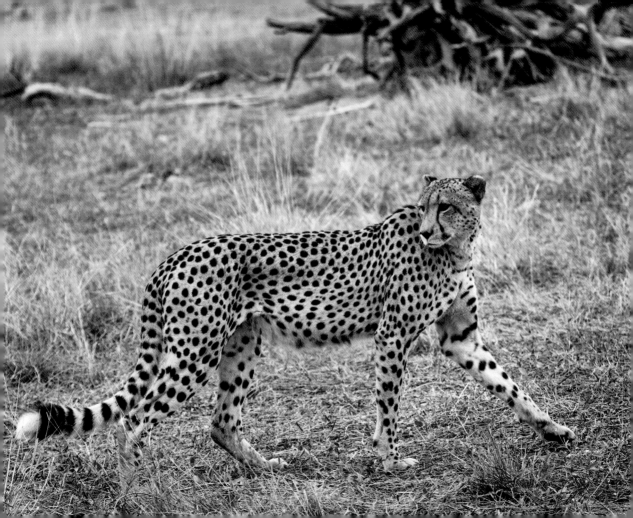

The first and simplest emotion we discover is curiosity.

Edmund Burke

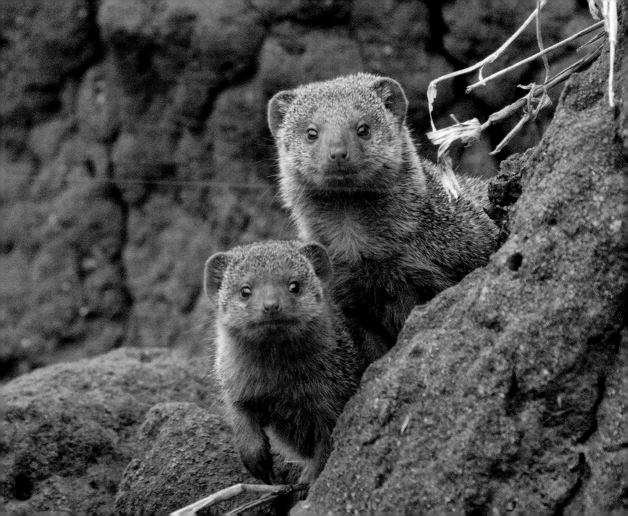

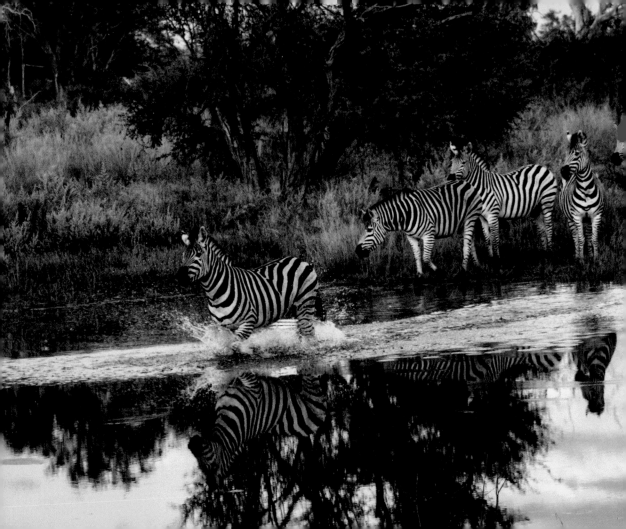

What is man without the beasts?
If all the beasts were gone, men
would die from a great loneliness
of spirit.

Chief Seattle

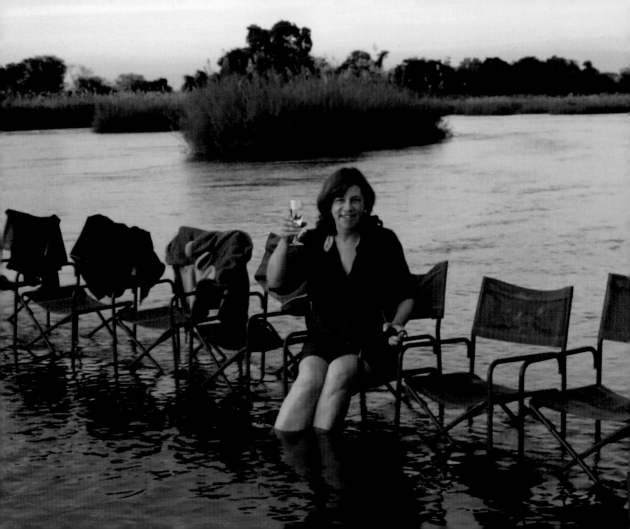

Judith Hamilton's 30 year career in the technology sector taught her the value of reinvention, which led to her current life of immersion in photography and nature. She was CEO of several small Silicon Valley based firms and has served on many public and private boards including Wildlife Conservation Society and The National Park Foundation.

Her previous book, "Animals A2Z" was widely distributed through the Bronx and Central Park Zoo stores and she has had numerous showings and private sales of her work.

Her exhibit of endangered animals was featured at Google world headquarters for 6 months. An extended version of this exhibit and an exhibit of baby animals hang permanently at Palo Alto Medical Foundation.

Judith can be reached at JudithHallHamilton@gmail.com. Her website is www.JudithHamiltonPhotography.com.

ISBN 978-0-692-57811-7

Library of Congress number 2015919674